PENGUIN BOOKS

# JOE & SALLY
## A LONG WAY FROM HOME

Willy Puchner was born in 1952 in Mistelbach, Austria. A freelance photographer and author since 1978, he has created a number of exceptional projects including his extended sojourn with Joe and Sally.

D1314733

# Willy Puchner

# JOE & SALLY

## A LONG WAY FROM HOME

Penguin Books

PENGUIN BOOKS

Published by the Penguin Group
Penguin Books USA Inc., 375 Hudson Street,
New York, New York 10014, U.S.A.
Penguin Books Ltd, 27 Wrights Lane,
London W8 5TZ, England
Penguin Books Australia Ltd, Ringwood,
Victoria, Australia
Penguin Books Canada Ltd, 10 Alcorn Avenue,
Toronto, Ontario, Canada M4V 3B2
Penguin Books (N.Z.) Ltd, 182–190 Wairau Road,
Auckland 10, New Zealand

Penguin Books Ltd, Registered Offices:
Harmondsworth, Middlesex, England

First published in Penguin Books 1993

1 3 5 7 9 10 8 6 4 2

Translation copyright © Viking Penguin,
a division of Penguin Books USA Inc., 1993
All rights reserved

Originally published in Austria as
*Die Sehnsucht der Pinguine* by Verlag Kremayr & Scheriau.
© 1992 by Verlag Kremayr & Scheriau, Wien.

ISBN 0 14 02.3118 8

Printed in Mexico
Set in Universal Light

# Introduction

Joe is forty-five inches tall and weighs just over twelve pounds. A cheap camera hangs around his neck. Sally is forty-three inches tall and weighs exactly eleven pounds. Their bodies are made of polyester and painted with black and white enamel; their ears, beaks, and chests are tinted with a yellow-orange watercolor; Sally's toenails are painted red. After every trip, they get a fresh coat of paint.

When travelling by plane or boat, Joe and Sally are packed in custom-made boxes. The fragile cargo lies on a bed of expanded resin and inflatable cushions. For the most part, however, Joe and Sally travel by car or are carried in backpacks. They always need two people to carry them from place to place. In the course of their travels, more than twenty porters have carried them with varying degrees of enthusiasm. I am the one person who has never left their side.

Everything began very much by chance. I had just completed my studies in social philosophy with the thesis *On Private Photography* and had no clear idea of what I should do. While in Vienna, I came upon the penguins in a small Viennese crafts shop called "ana plus." When I returned with my new purchases to my apartment, I noticed that the penguins resembled those amateur photographers I had theorized about for two years. I no longer associated the penguins solely with Vienna but began to imagine them in different locations and settings. One Sunday afternoon I brought them along for a ride with some friends. Only much later did I realize that that outing was the beginning of a project. Thus *Joe and Sally* came slowly into

being. *Joe and Sally* is my—our—longing to travel to foreign places and to fix our desires and yearnings in photographic images.

For three years, Joe, Sally, and I went from place to place. I encountered many people who laughed or were baffled; often they would follow me and ask questions: "Why penguins? Why exactly penguins?"

Most of the time I explained that I love to be photographed. What would make me most happy would be to see myself in countless photo albums all over the world. With Sally and Joe, I am assured of being photographed a lot. I remember one snapshot in front of the pyramids in Giza: a Japanese man was holding the reins of a camel. I stood next to him smiling. My friend Anneliese was sitting on the motorcycle. Joe and Sally were strapped to our backs. A second Japanese man photographed us. This lovely group photo now exists somewhere in Tokyo or Nagasaki. Even if I never see these photographs, I like to visualize them in my imagination.

It is nice to be spoken to often and to serve as a kind of object of amusement. We received the most animated reactions in New York: cars followed us and honked their horns, pedestrians stopped and clapped. There was one particularly wonderful experience: a friend and I boarded an elevator with Joe and Sally in order to go up to the fortieth floor and take pictures on the terrace. Thirty people were allowed on the elevator. Twenty-five were already on board when we squeezed in with the penguins on our backs. Joe and Sally faced the passengers behind us. It was dead silent. Suddenly someone got the giggles and by the time we reached the fortieth floor, everyone was laughing.

While travelling in northern Germany in a small village on the Elbe, Lutz and I ran into a woman about to enter her house. When she saw the penguins, she began to laugh hysterically; this was, of course, a familiar reaction. But she followed us and yelled: "The penguins have come home! Finally. The penguins have come home!" Nearly out of breath, she explained that her husband had been working as a technician for the last year and a half in Antarctica. And almost every time a letter came from him it was accompanied by a picture of a penguin.

Joe and Sally always travel together. They look as if they were made for each other and could never leave one another. Not only is distance part of our nostalgia, but also nearness to someone we love. It would be nice to travel for a while with a loved one and with hope as one's baggage.

Lately, I've noticed that I am more and more attracted to people who stand at a crossroads in their lives. They may be old friends or new acquaintances, but what they share is a sense of hopeful anticipation about the future and the desire to push on. Perhaps I have learned this on my trips: many small tests of one's courage are necessary.

I have no idea how this project will end; I have only a vague idea of where it all leads, but clearly I must find a means of "coming home." At first I thought I would frame the photographs, hang them on the wall, perhaps paste them in an album or prepare an exhibit. But the project concerns me too intimately to end up pasted in a photo album.

Alternatively, I could carry Joe and Sally to Antarctica and leave them there. A friend who works for Greenpeace told me about a panoramic lookout where tourists

go to observe penguins. I thought of installing Joe and Sally on the lookout and therewith end the project. It would have made for a nice picture: the widely travelled penguins functioning as a kind of mirror for the tourists: in looking at the penguins, they would look at themselves. But I have set that idea aside as well.

So I am faced with a third possibility: the story has no end. I am no longer afraid people will think I'm a lunatic who can't get rid of his penguins. I can get rid of Joe and Sally very easily; perhaps they have already become independent anyway. But there remains a far more important question: what to do with my yearning—with my desire to be in a different place and time? Even if the penguins are only a metaphor for nostalgia, why should it ever end?

—Willy Puchner

**Special thanks to those who for longer and shorter stretches
carried the penguins and who more or less
were forced to bear with me as well.**

Daniela Bilek (Mistelbach, Lower Austria)
Lisi Breuss (Vienna)
Clara Delfsma (Wolvega, Holland)
Ayse Durakbasa (Istanbul, London)
Raphael Eisikovic (Vienna, Bologna)
Stephania Grimandi (Bologna)
Christa Hämmerle (Vienna)
Anna Maria Heigl (Vienna)
Annegret Hering (Pottum)
Peter Hermann (Vienna)
Brigitte Hilzensauer (Vienna)
Seishi Ishida (London)
Christian Jauernik (Vienna)
Gerhard Kleindl (New York)
Ilse Lahofer (Mistelbach)

Maria Meier (Mistelbach)
Tommy Müller (Mistelbach)
Raphael Abd El Naby Sultan (Cairo)
Gerhardt Ordnung (Vienna)
Anneliese Paulhart (Vienna)
Walter Paulhart (Vienna)
Katharina Pfusterschmid (Vienna)
Bertie Plaatsman (Diemen, Holland)
Claudia Preschl (Vienna)
Arno Ritter (Vienna)
Theodor Scheffl (Vienna)
Wally Sladek (Berlin)
Doris Stoisser (Vienna)
Petra Suko (Vienna)
Lutz Tornow (Hamburg)

# JOE & SALLY

## A LONG WAY FROM HOME

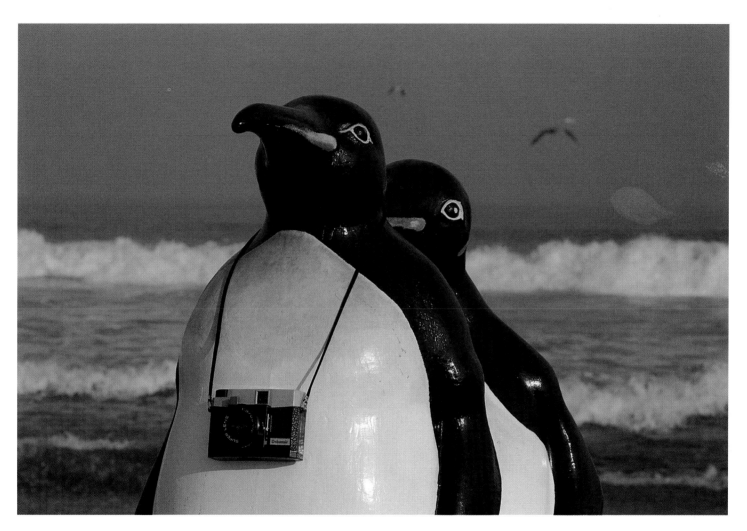

Longing

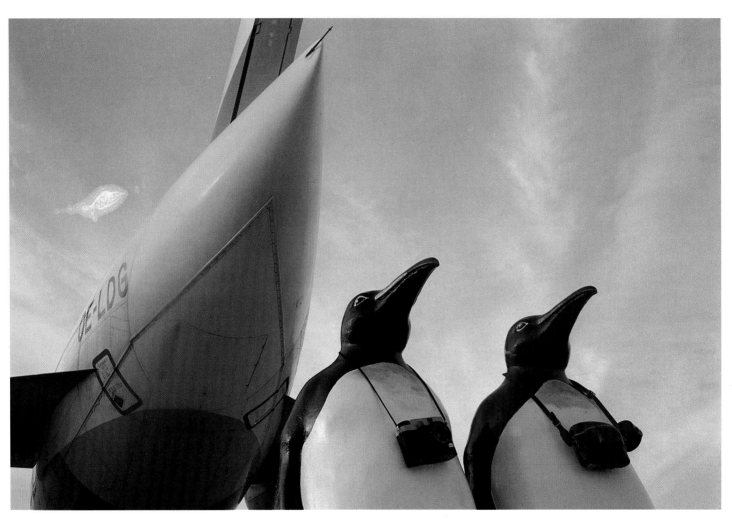

Vienna-Airport

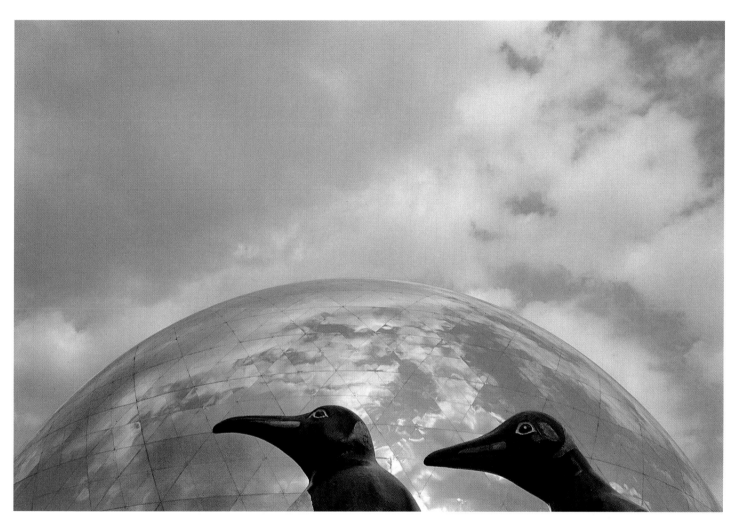

Paris, La Villette

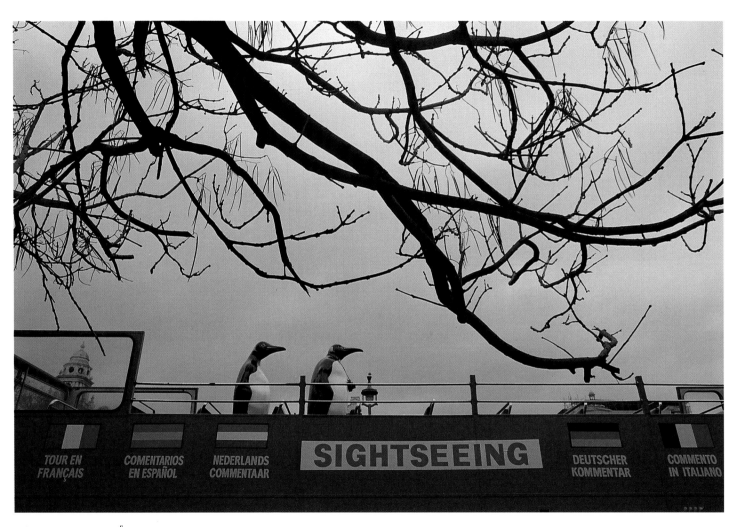

Sightseeing in London

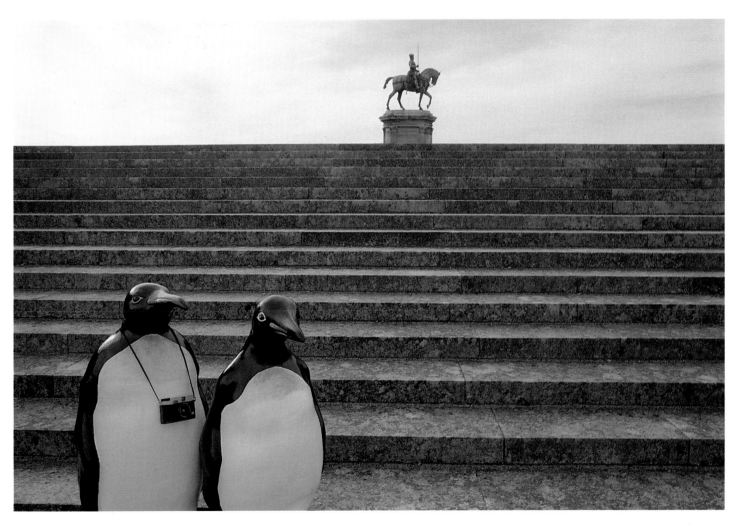

Chantilly

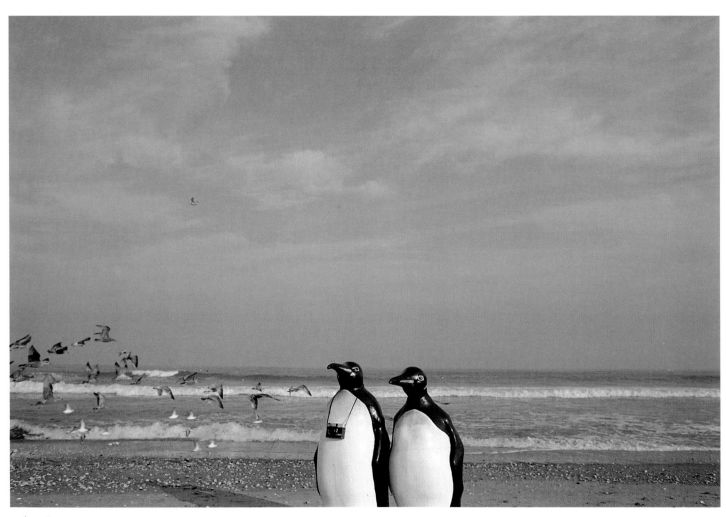

New Jersey, U.S.A.

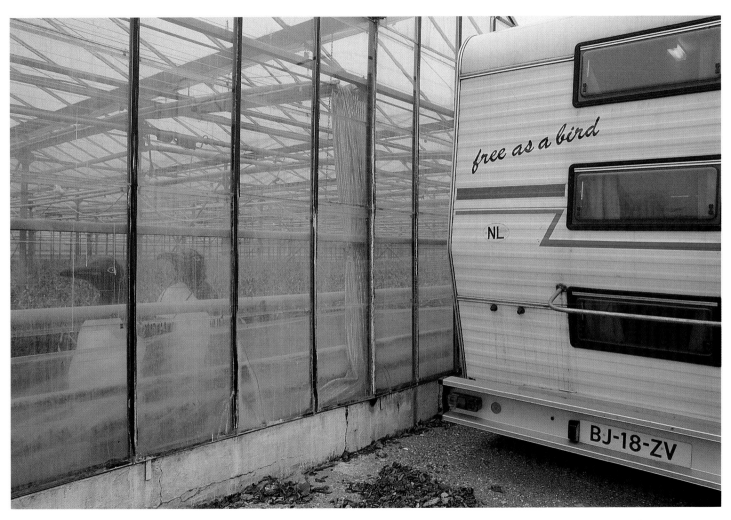

Rotterdam

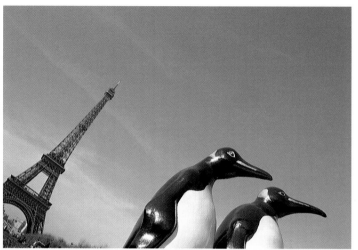
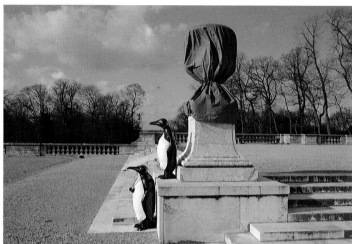
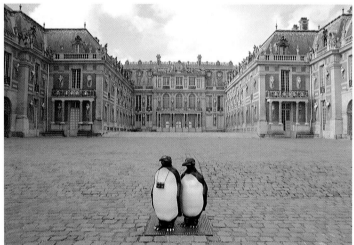
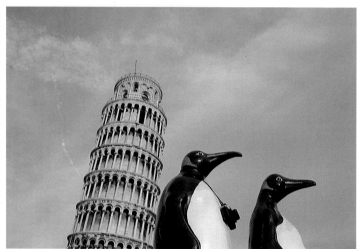

Paris, Versailles, Pisa

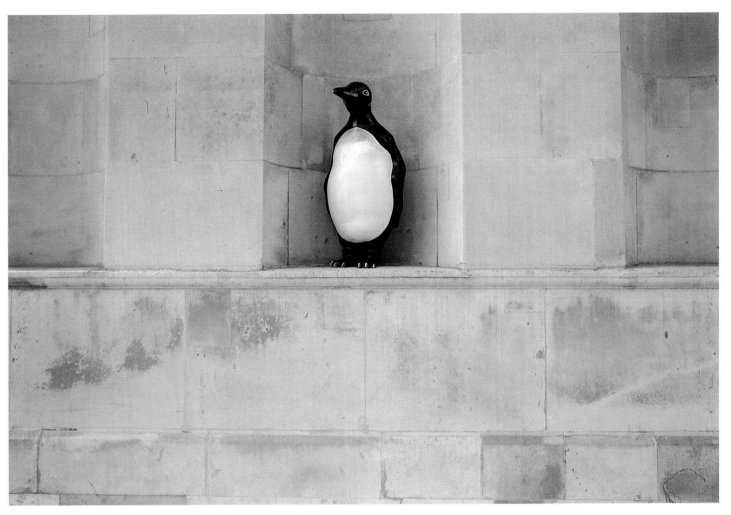

Sally forever

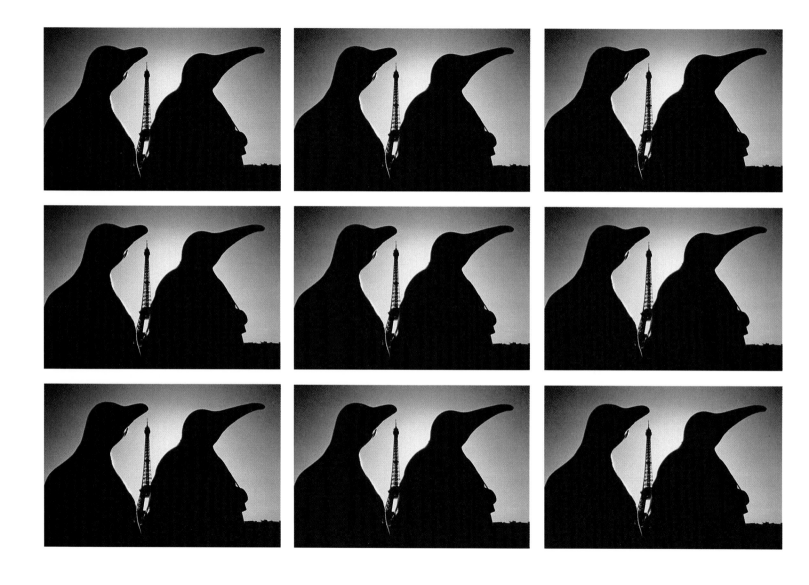

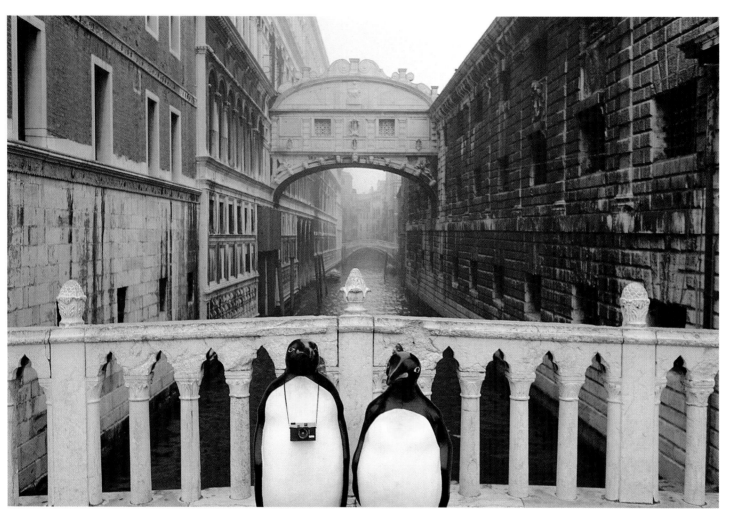

Ponte dei Sospiri

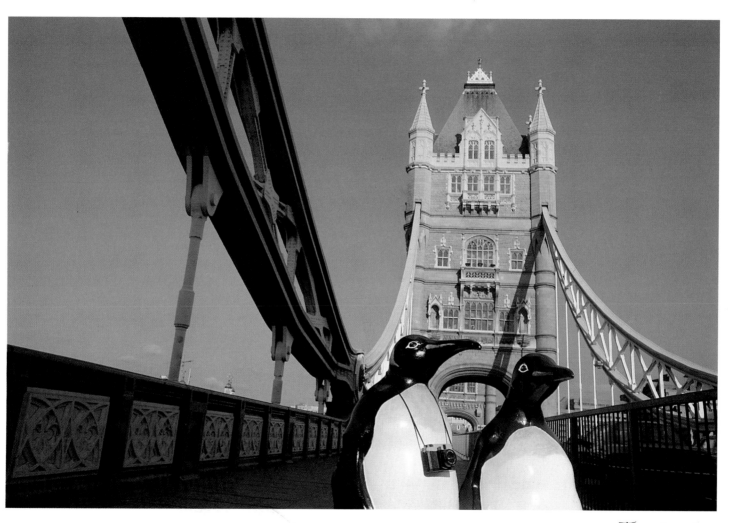

Tower Bridge

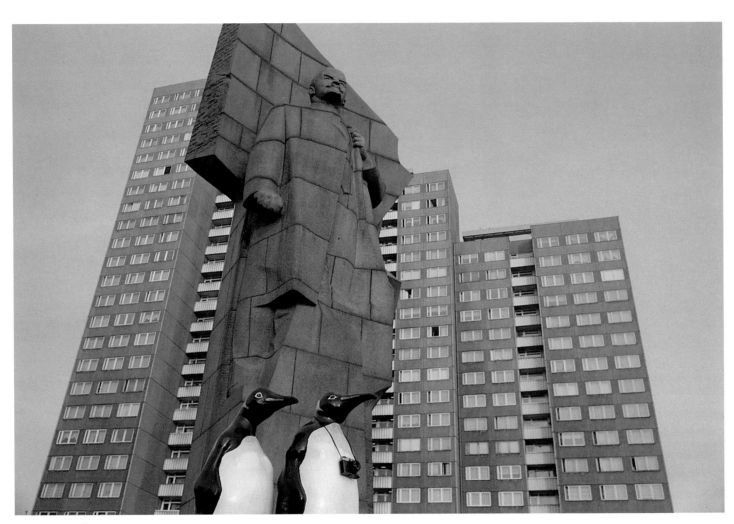

Lenin in Berlin

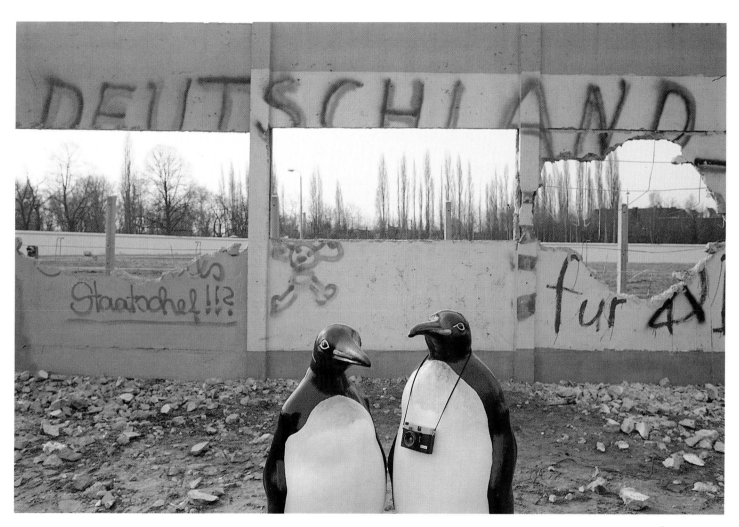

February 27th, 1990

New York, Memorial

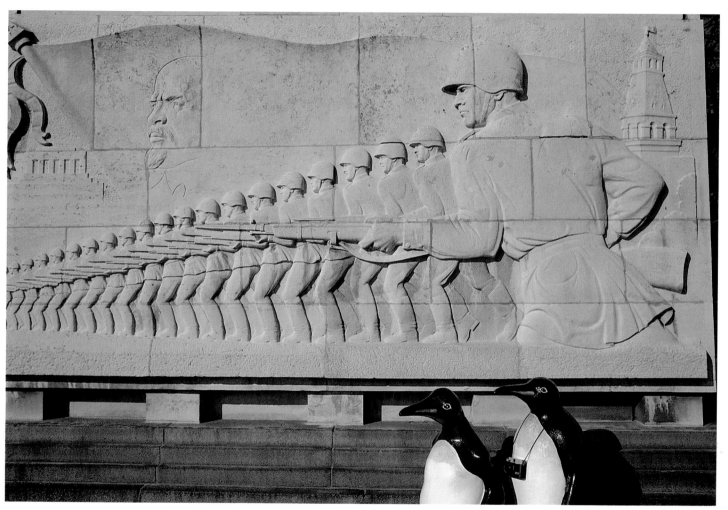

Berlin

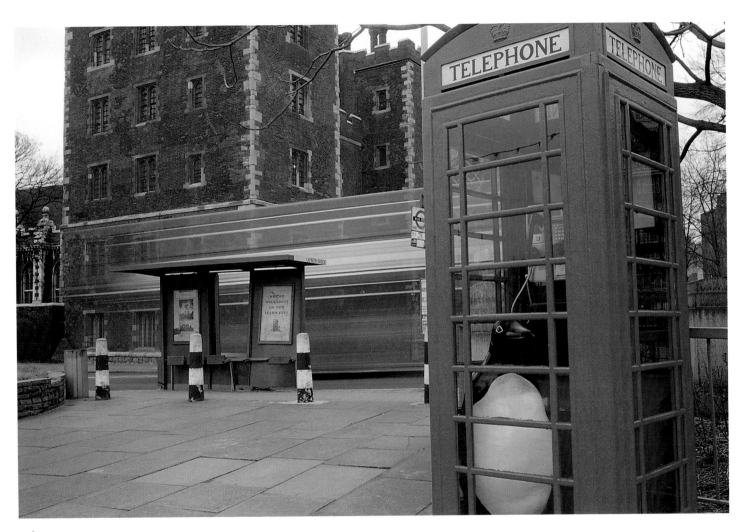

London

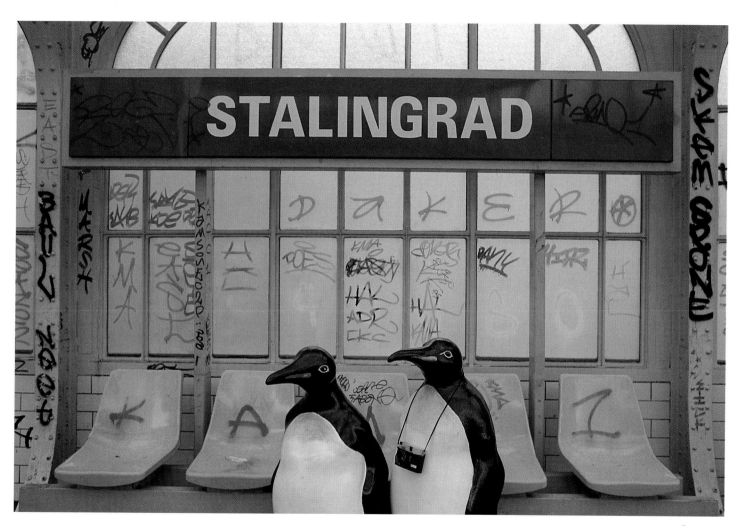

Paris

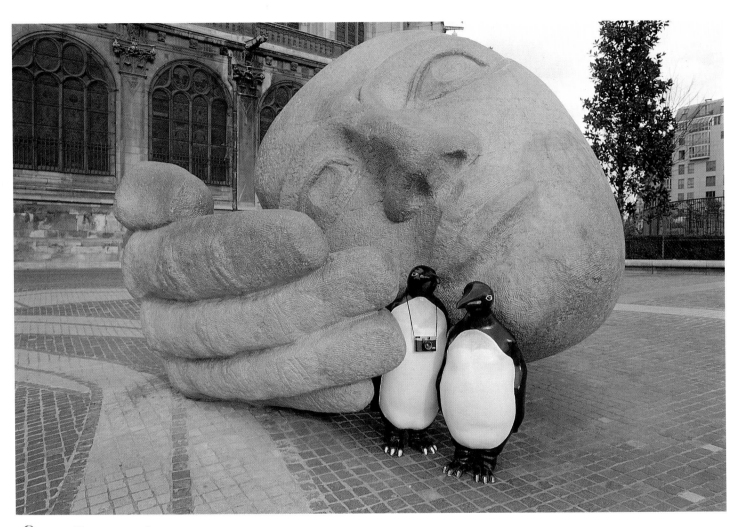

Paris, Place R. Cassin

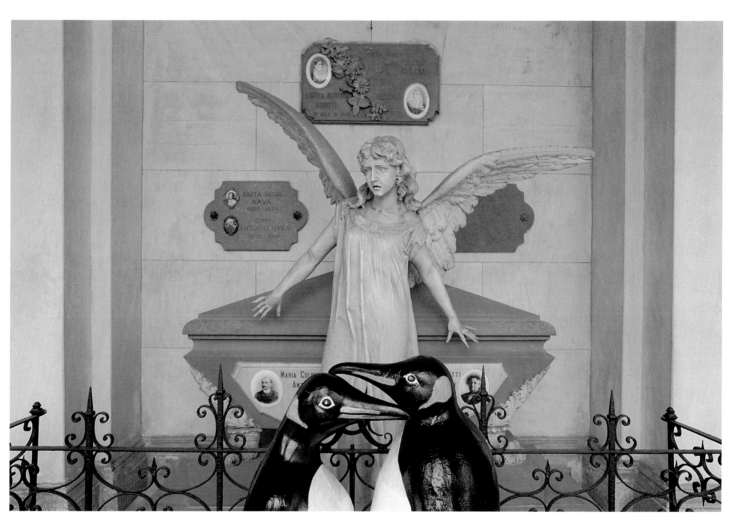

Verbania, Lago Maggiore

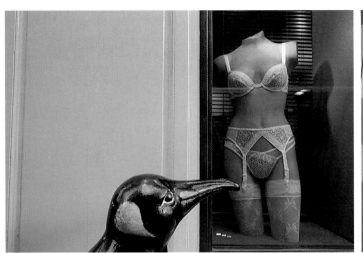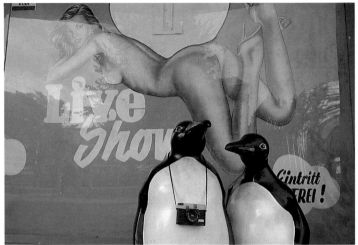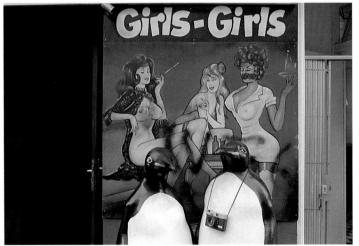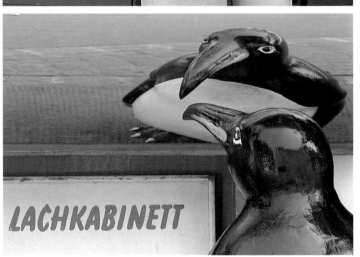

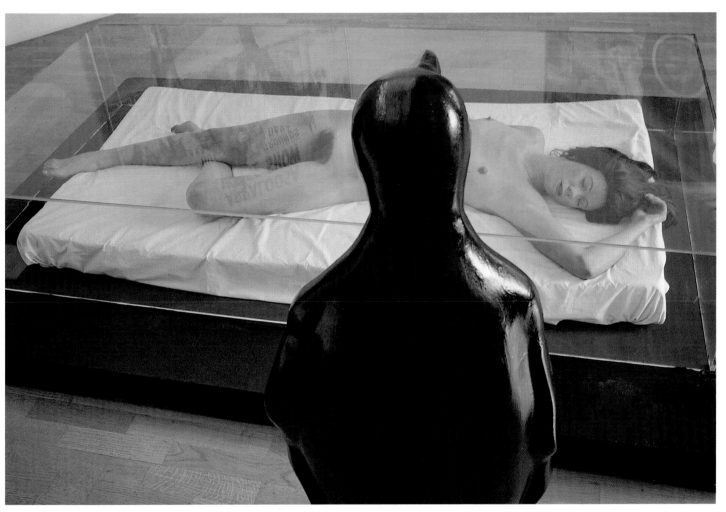

Vienna, Museum of Modern Art

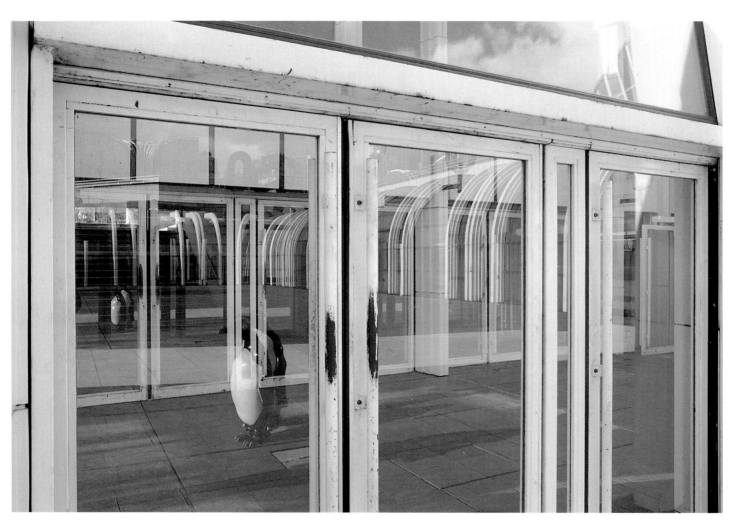

Paris, Les Halles

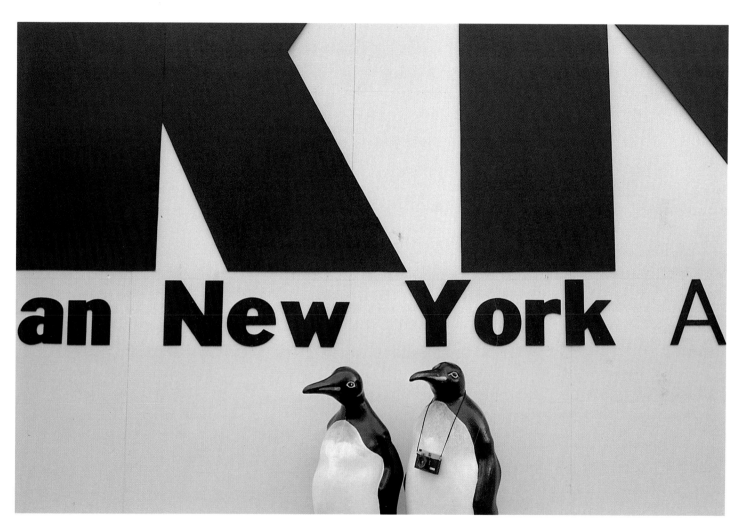

London

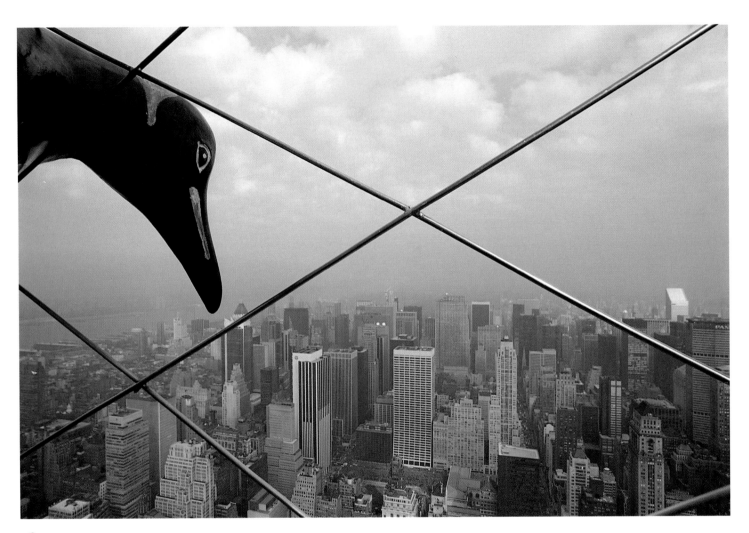

Manhattan

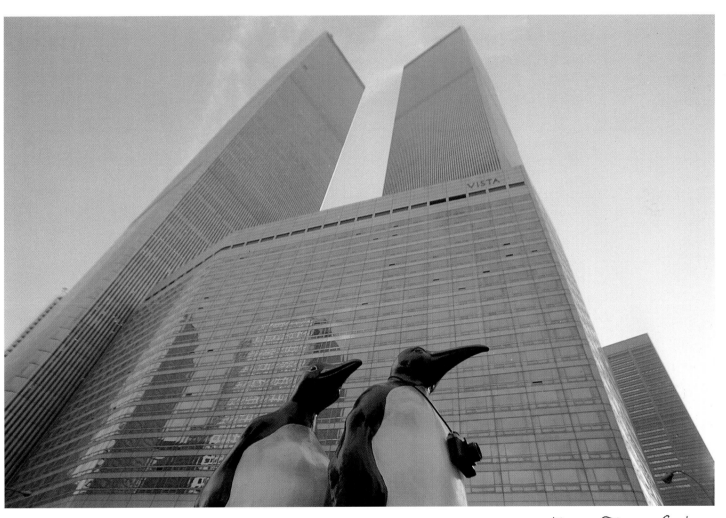

World Trade Center

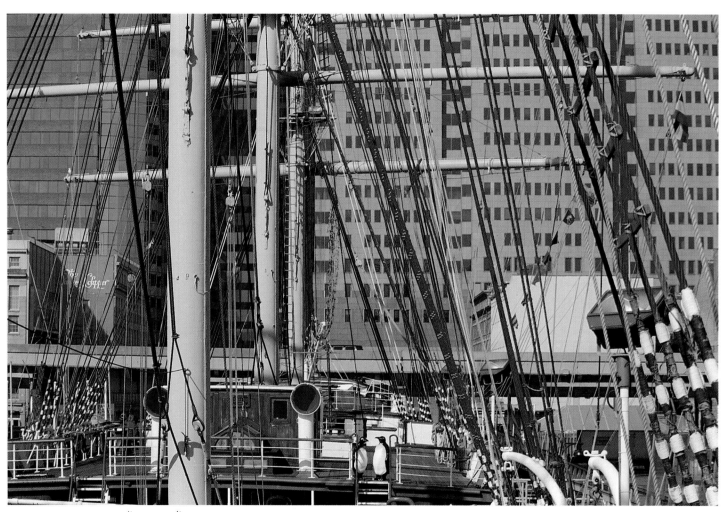

New York, aboard "Peking"

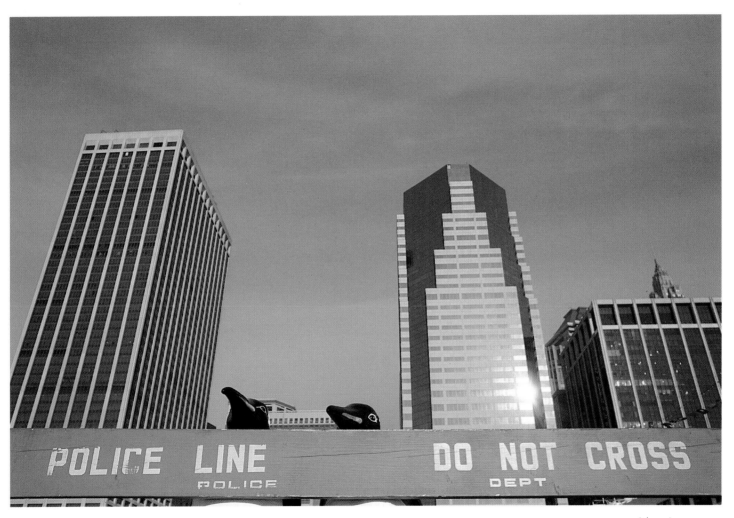

POLICE LINE
POLICE

DO NOT CROSS
DEPT

New York

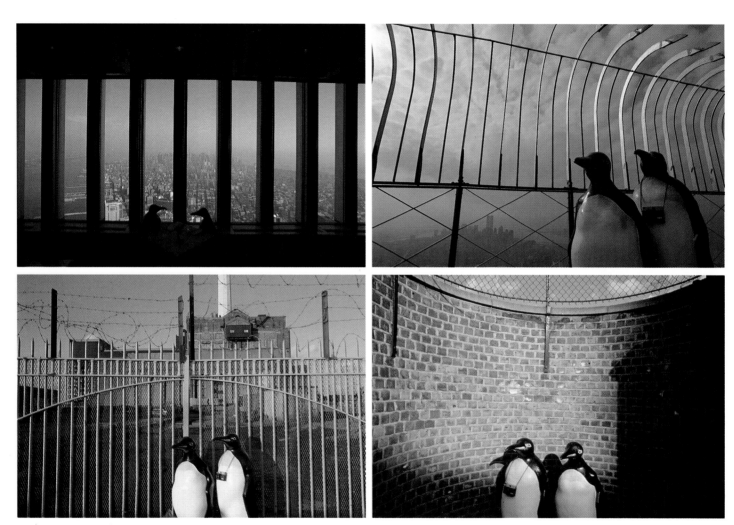

New York, London

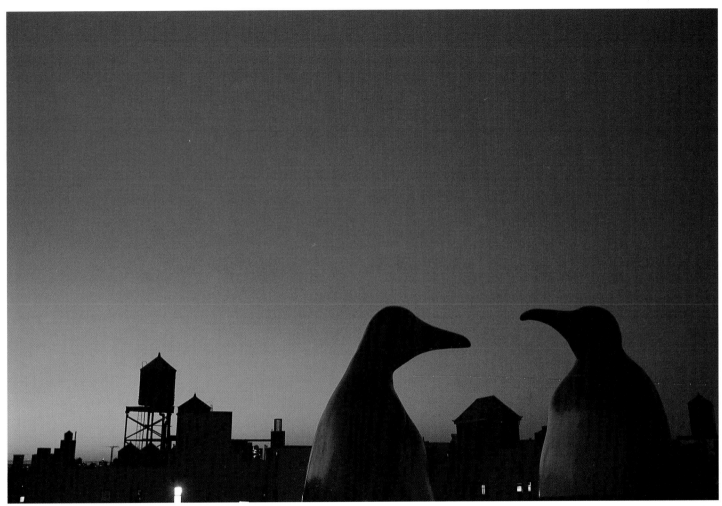

New York

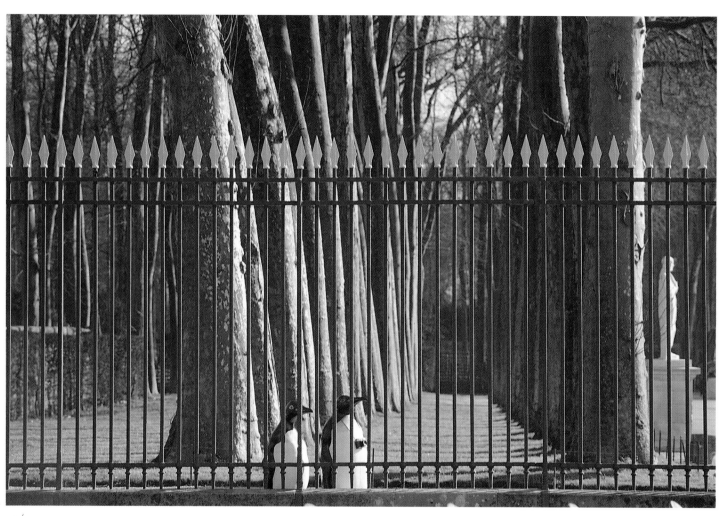

Versailles

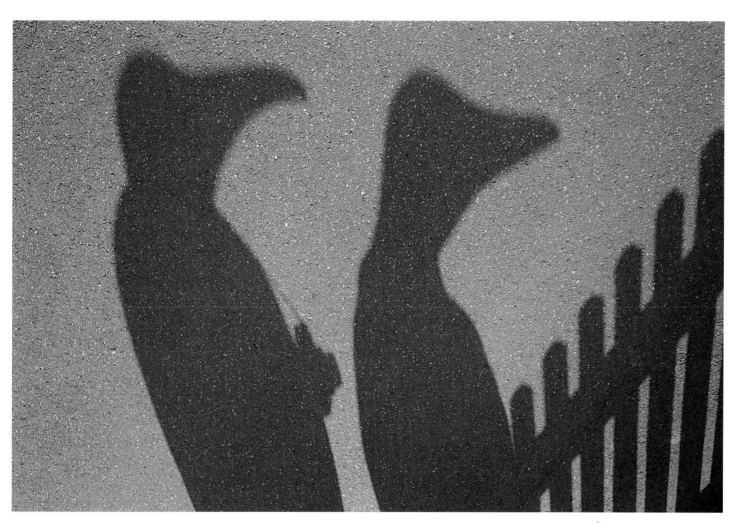

Jork, Germany

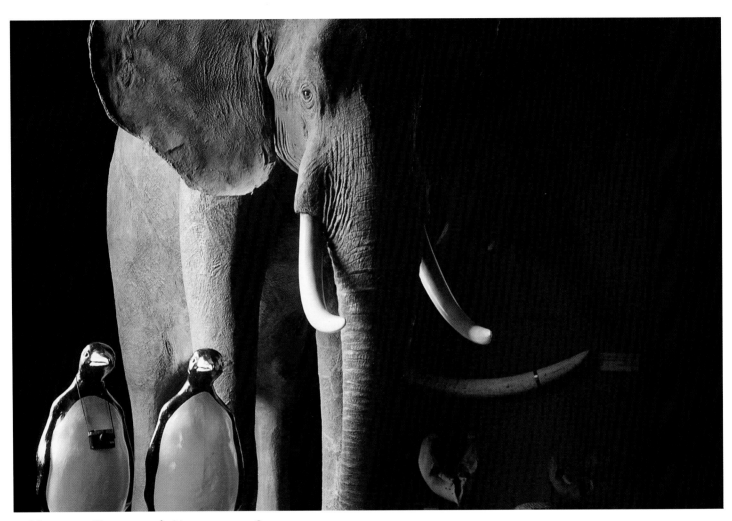

Vienna, Museum of Nature and Science

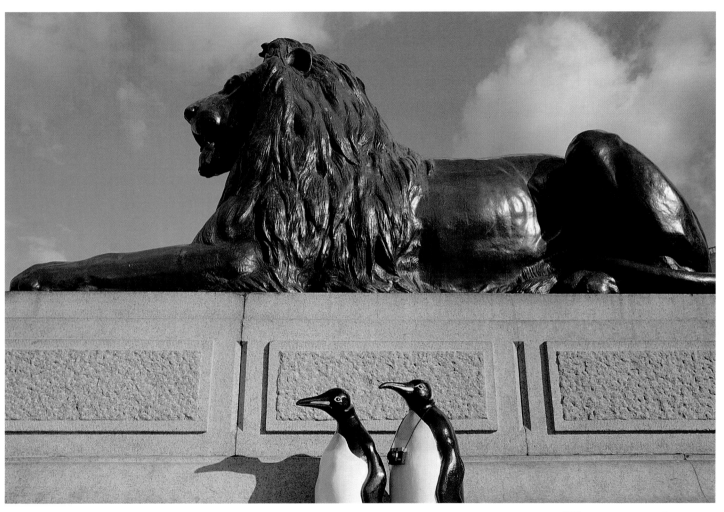

Trafalgar Square

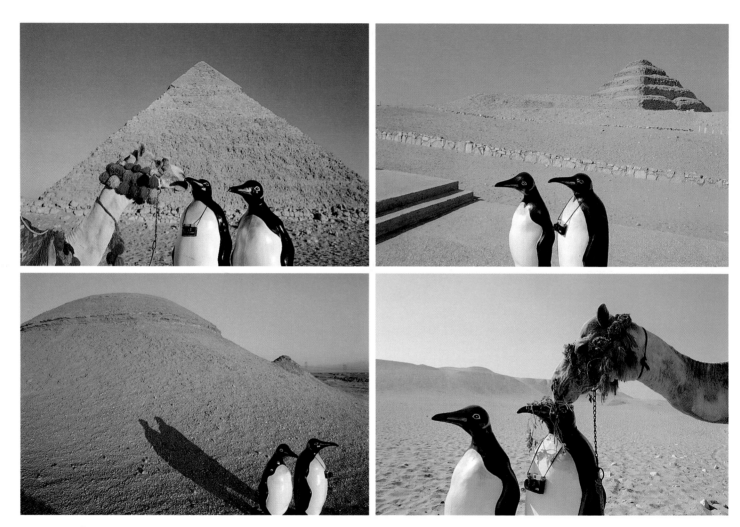

Gizeh, Sakkara, El Faiyum

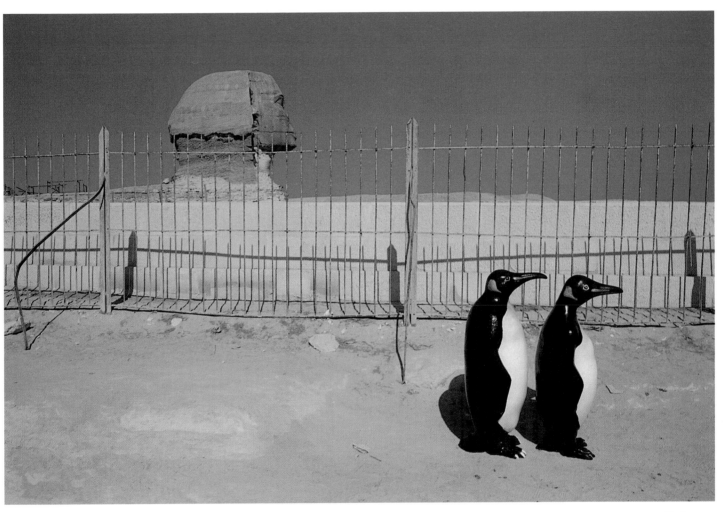

Sphinx

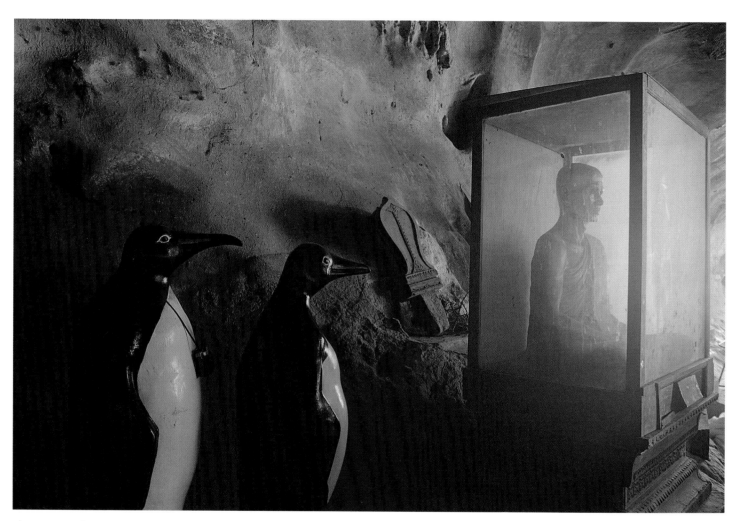

Krabi, Thailand

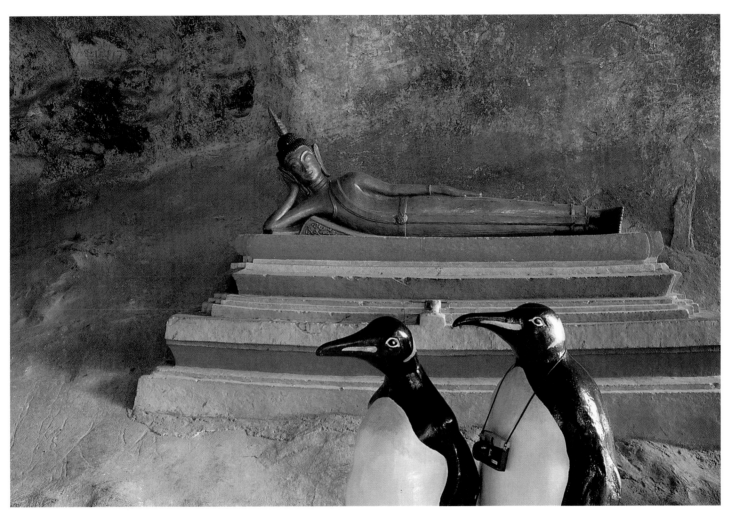

Krabi, Thailand

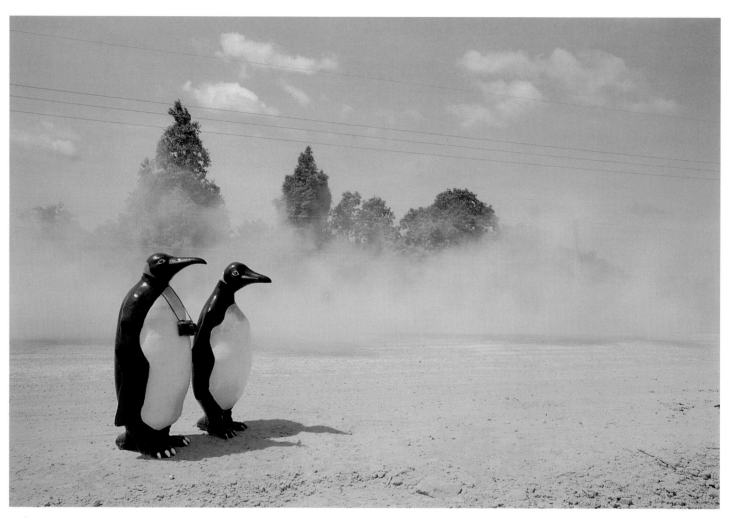

On the road

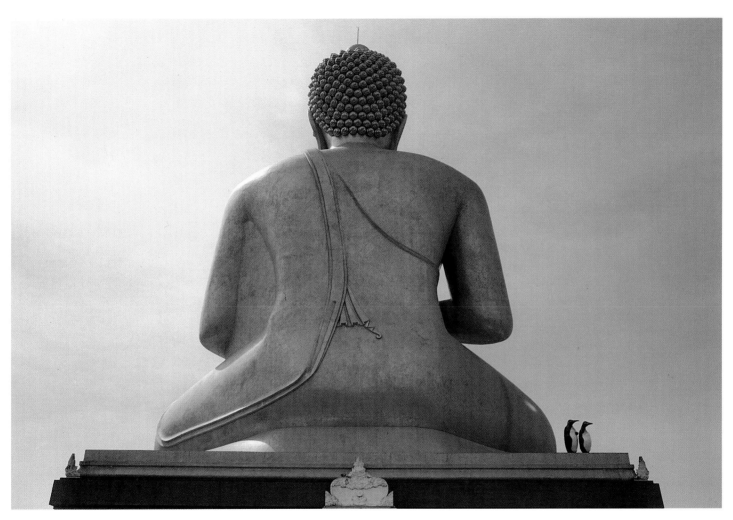

Narathiwat, Thailand

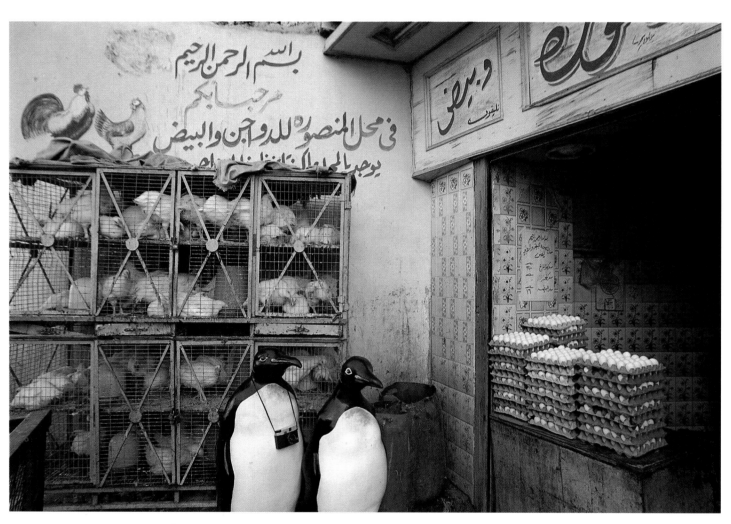

El Faiyum, Egypt

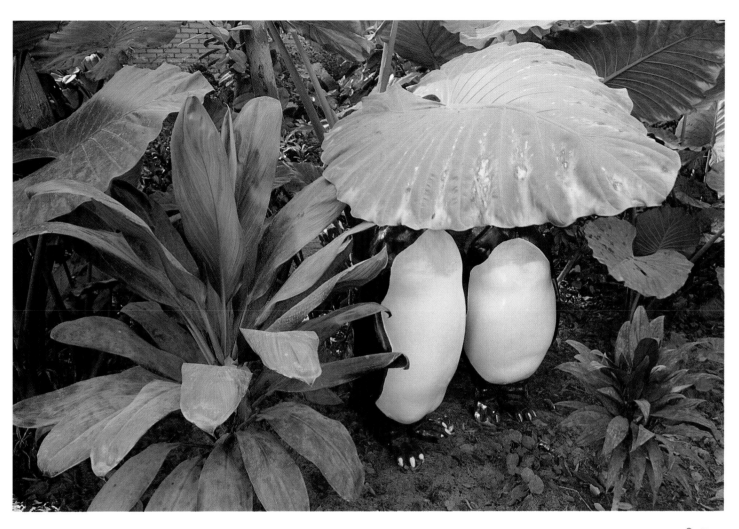

Cairo

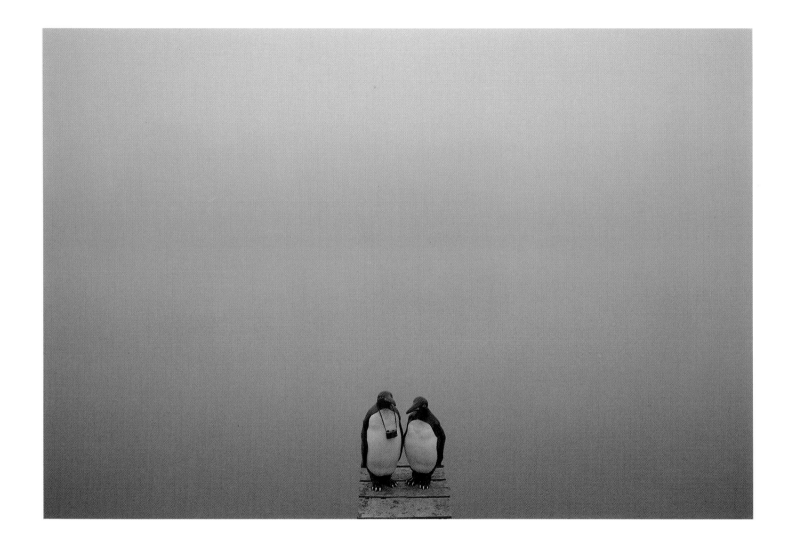

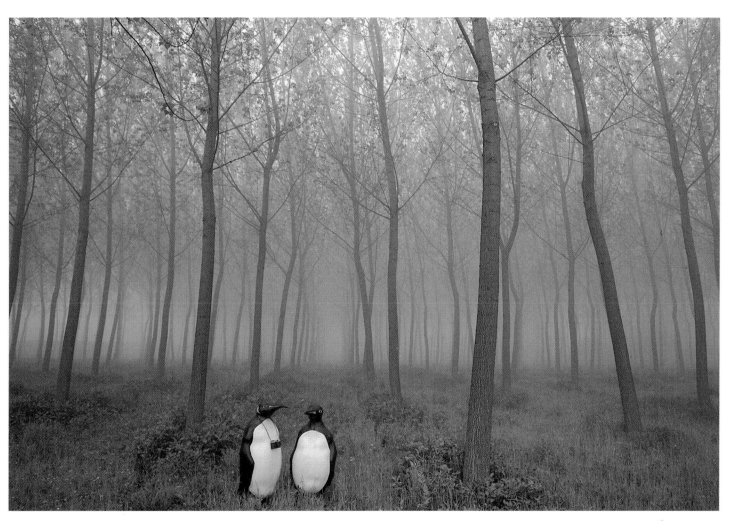

Treviso

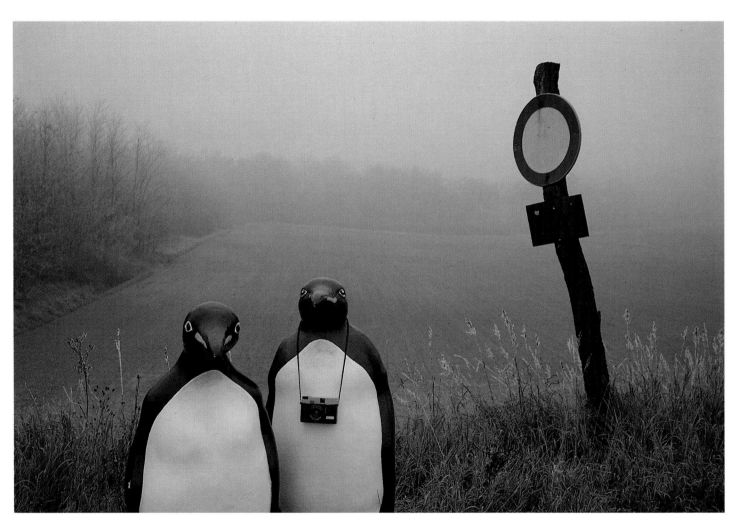

Mistelbach

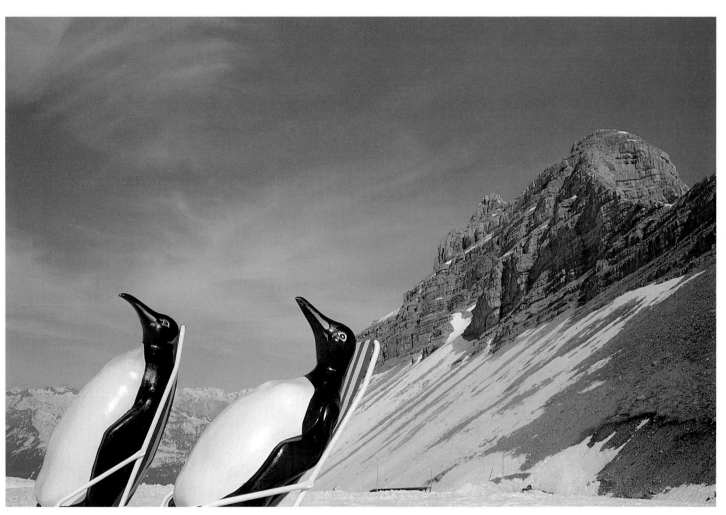

Madonna di Campiglio

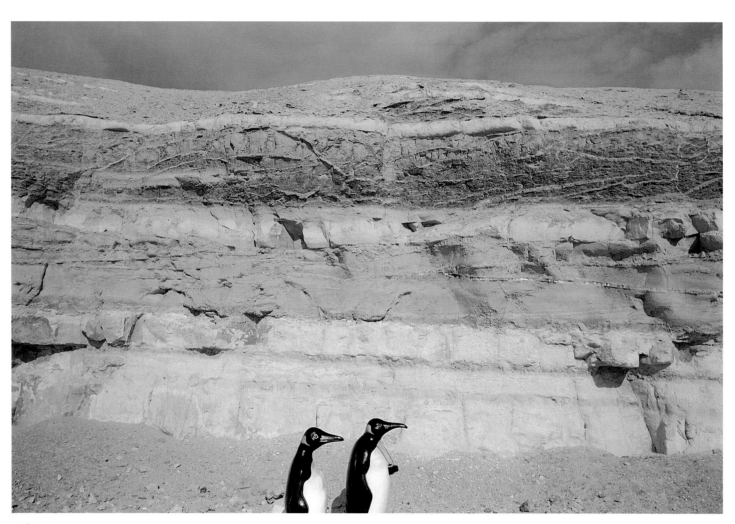

Gizeh

Songkla, Thailand

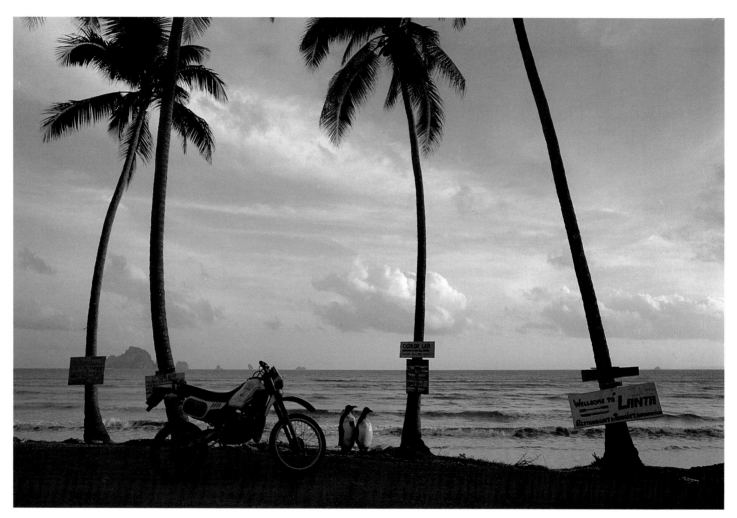

Krabi, Thailand

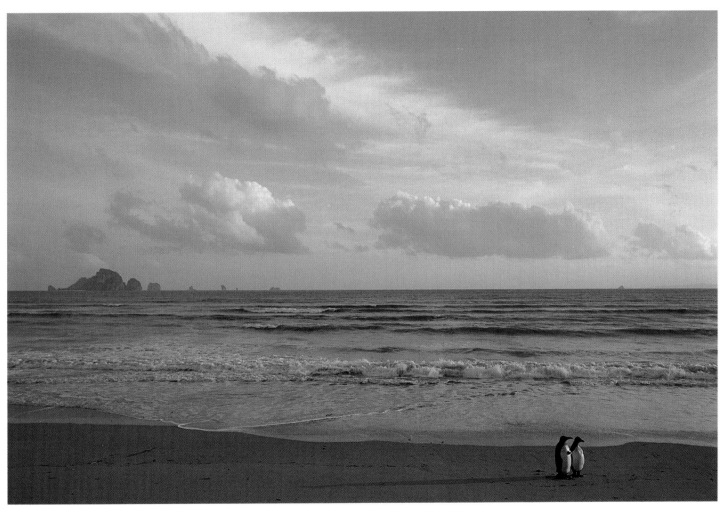

Krabi, Thailand

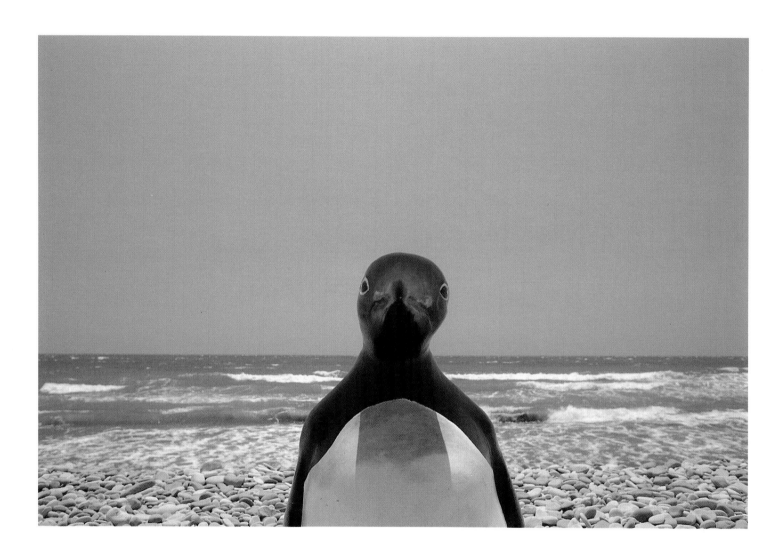

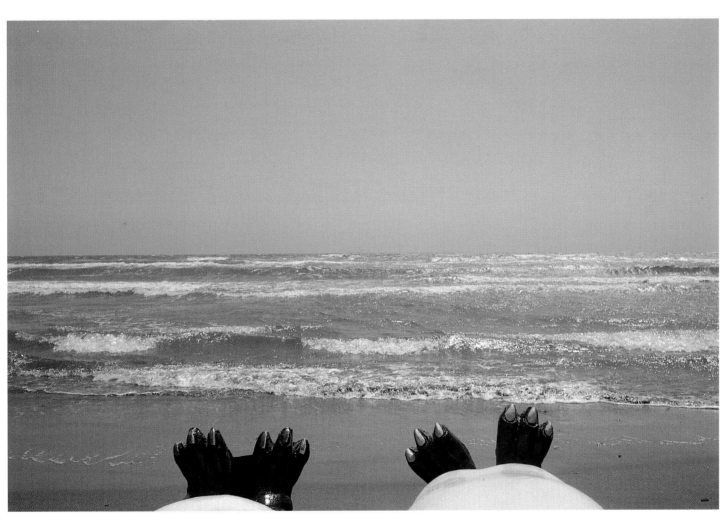

Weekend

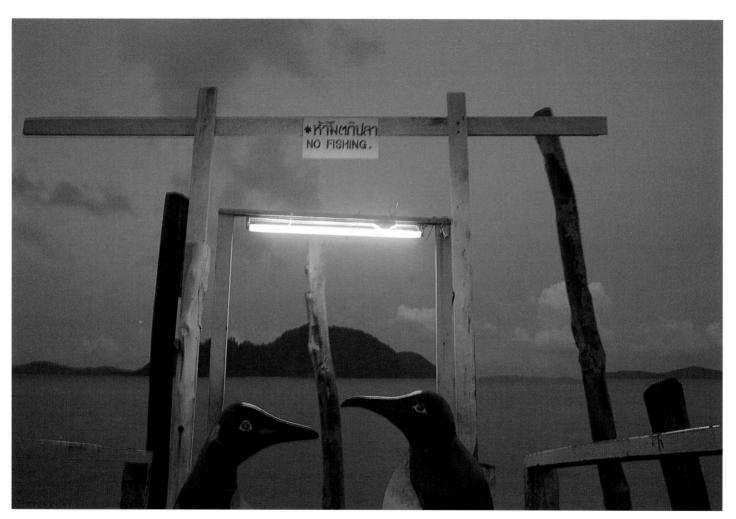

Phuket, Thailand

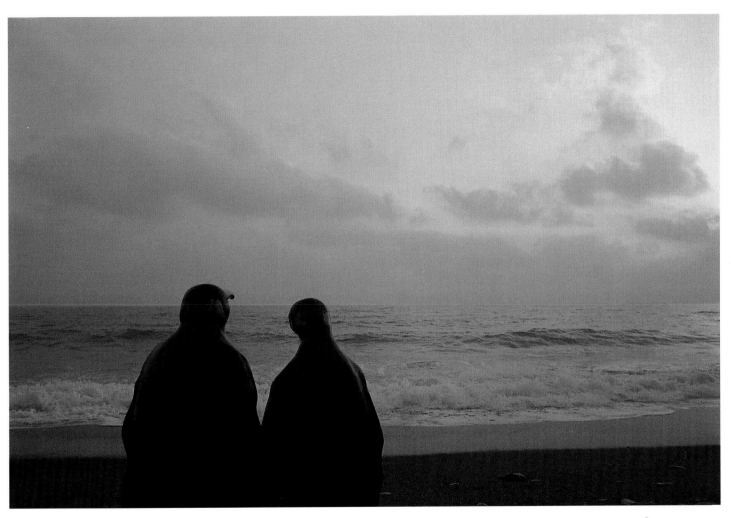

Coral Bay

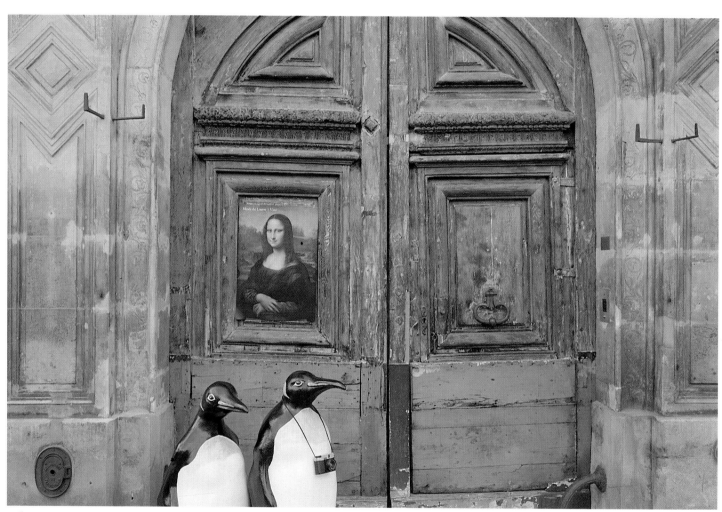

Paris

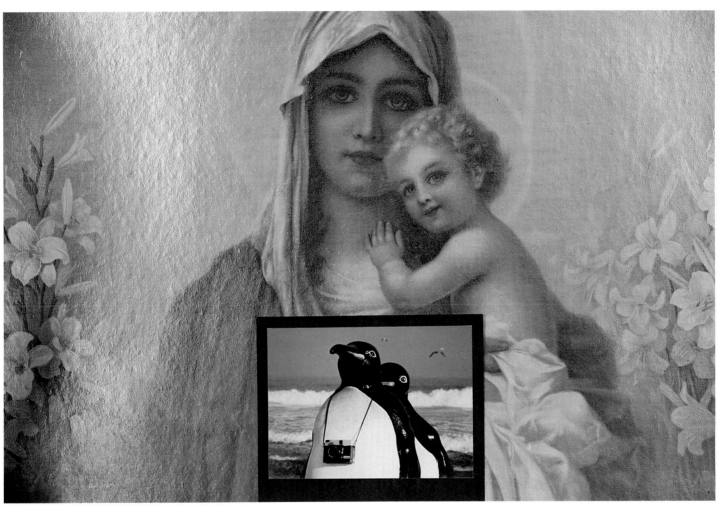

At home

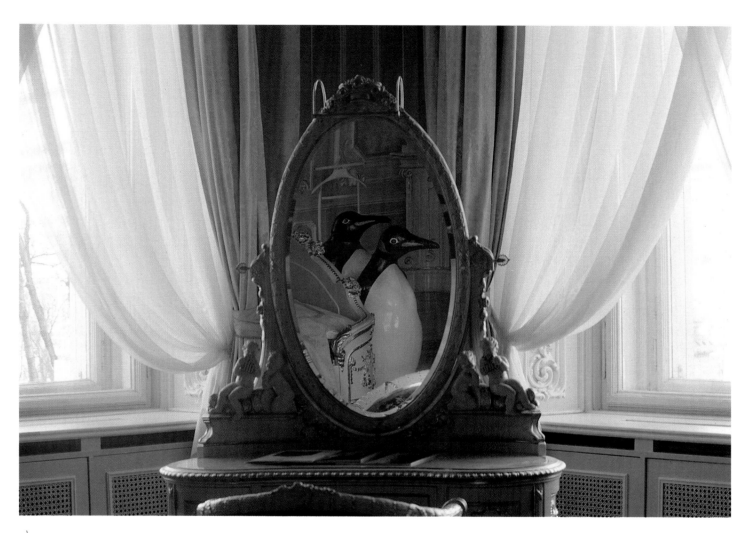

Vienna

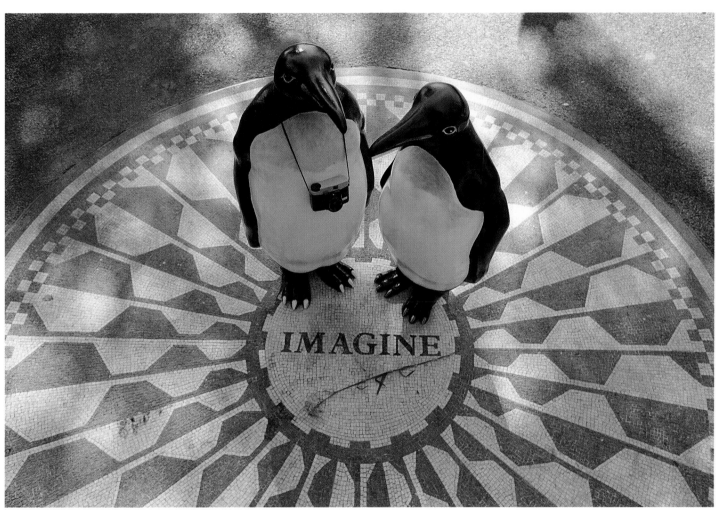

IMAGINE

John Lennon im Central Park

*Joe and Sally* required meticulous organization and provided an opportunity for me to indulge one of my greatest passions: bookkeeping. These few pages of the itinerary that I kept during my travels will give the idea. If I had lost Sally and Joe, I would have been very sorry; if I had lost my itinerary, however, it would have been like losing part of myself.

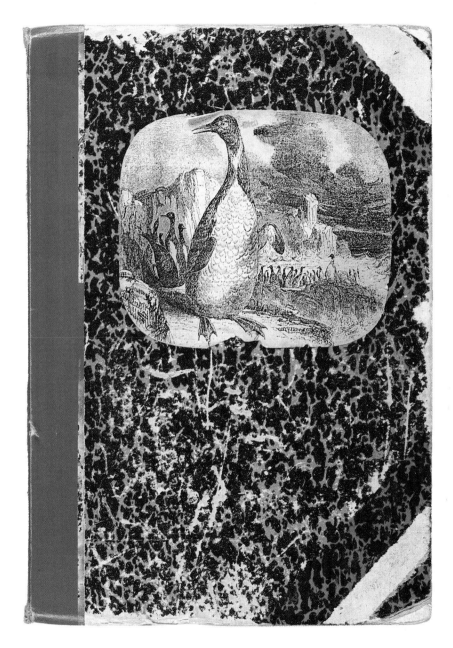

## STATIONEN:

| # | | | |
|---|---|---|---|
| 1 | Rathaus, Parlament, Museum Moderner Kunst | WP, Ernestine, Rosemarie, Christkem | 18·1·88 |
| 2 | Prater | WP, Christian | 28·1·88 |
| 3 | Zentralfriedhof | WP, Brigitta | 2·10·88 |
| 4 | Naschmarkt | WP | 3·10·88 |
| 5 | Karlsplatz | WP, Annegreth | 4·10·88 |
| 6 | Café Sperl | WP | 5·10·88 |
| 7 | Stephansplatz | WP, Peter, Christian | 6·10·88 |
| 8 | Naturhistorisches Museum | WP, Peter | 11·10·88 |
| 9 | Franz-Josef Bahnhof | WP, Anneliese | 8·10·88 |
| 10 | Ottakring | WP, Christian | 9·10·88 |
| 11 | Westbahnhof | WP, Anneliese | 9·10·88 |
| 12 | Stadtpark | WP, Gerhard | 4·10·88 |
| 13 | Oberlaa (1) | WP, Christa | 14·10·88 |
| 14 | Heeresgeschichtl. Museum | WP, Claudia | 16·10·88 |
| 15 | Nationalbibliothek | WP, Raphael | 18·11·88 |
| 16 | Donau | | 24·11·88 |
| 17 | Oberlaa (2) | WP, Christa | 27·11·88 |
| 18 | Amalienbad | WP | 28·11·88 |
| 19 | Pinguine, AuA | WP, Walter | 29·11·88 |
| 20 | Kleinviertel, Atelier Mrsa | WP, Daniel, Ilse | 26·12·88 |
| 21 | Wirkwaschbaum, Pötzleid | WP | 6·1·89 |
| 22 | Imperial | WP, Anneliese | 18·1·89 |
| 23 | Haydnbräuwashaus, Strudelhofstiege | WP, Christa, Aysha | 19·1·89 |
| 24 | Marmorsl, Börgeralm | WP, Christa | 21-23·1·89 |
| 25 | Madonna di Campiglio, Dolomiten | WP, Raphael, Stephania | 24·3-2·4·89 |
| 26 | Venezia, Chioggia | WP, Christa | 24·3-2·4·89 |
| 27 | Mühlviertel | WP, Ilse, Markus | 13-14·4·89 |
| 28 | Marcel, Kleinviertel | WP, Petra | 15·4·89 |
| 29 | Zypern | WP, Irene, Karin | 18·6-2·7·89 |
| 30 | Hamburg | WP, Lutz | 7·9-14·9·89 |
| 31 | New York | WP, Anna | 19·11-3·12·89 |
| 32 | Ägypten | WP, Anneliese | 20·11-5·12·89 |
| 33 | Schönbrunn | WP, Anneliese | 13·1·90 |
| 34 | Mistelbach, Schleur | WP | 12·1·90 |
| 35 | Holland und Ostkammer | WP, Anneliese | 19·1·90 |
| 36 | Schönbrunn Zoo, Naschmarkt | WP, Walter | 28·1·90 |
| 37 | Paris | WP, Walter | 31·1·90 - 1·3·90 |
| 38 | London | WP, Walter | 31·1·90 - 1·3·90 |
| 39 | Berlin | WP, Walter | 1·3·90 |
| 40 | At home | WP | 14·4·90 |
| 41 | Flohmarkt, Naschmarkt | WP, Ursi | 18·5·90 |
| 42 | Flughafen Wien | | 29·5·90 |
| 43 | Thailand | WP, Aiko | 15·6 - 7·7·90 |
| 44 | Wien, Tiergarten | WP, Doris | 21·8·90 |
| 45 | Wienaus | WP | 2·10·90 |
| 46 | Köln, Holland | WP, Li | 7·12·90 - 13·12·90 |
| 47 | Basel, Mailand, Florenz, Rom | WP, Arno | 9·2·91 - 20·2·91 |
| 48 | Wien, Schönbrunn, Palmenhaus, Kunsthhalle | WP, Arno | 14·3·91 |
| 49 | | | |
| 50 | | | |
| 51 | | | |

## ALLGEMEINE INFORMATIONEN:

Cik, Tel ... Bernharda 2/0 ... ...

Pinguine in Patagonien — Tel. 5272341 ...

**SCHACHTEL** : Maße: 55 cm breit, 59 cm hoch, 120 cm lang

Joe & Sally are
WELCOME TO AUSTRIAN AIRLINES

Pastini fabrichten : A.D. Hunzler, 30, Boulevard de Invalides, 75067 Paris, Tel. 7052240

Polyester 2 Komponenten-Kitt :

Aufblasbare Objekte : durch Kurt Majauschek, 13, Sechshauserstr. 1/13 - Tel. 3538714 ...

**Minus delta, das Bangkok Projekt**

Neue NUMMER!!
+ 43/535/388

Richard Strauss, Also sprach Zarathustra

**MINIMALE AUSRÜSTUNG**

Heiligenbilder, Kreuze, Waffen, Hirschgeweihe, Schmuck, Alben, Postkarten ...
[EDMOND JABÈS]

**CARNET:** Bei jeder Einfuhr bzw. Ausfuhr das
Carnet abfertigen lassen und die Zoll ...

[1 JAHR]

POSTKARTEN:

*Es gibt mehr POESIE in einem Häuserblock New Yorks als auf tausend bis tausendhundert Wegen (?)*

# NEW YORK - KONTAKTE

Gespräche mit:

*NOT ONLY ARE YOU SEEING THE SIGN BUT YOU ARE BECOMING THE SIGN... Eva Leak* ♥

ÄGYPTEN-

Postkarten

USA-Kontakte:

(PINGUIN)

بسيط

لبسيط

Briefe:

Kamele:

Sonstiges:

Kamele ②:

Pinguine: (coloriert)

Bazar:

STEMPELN

MONEY:

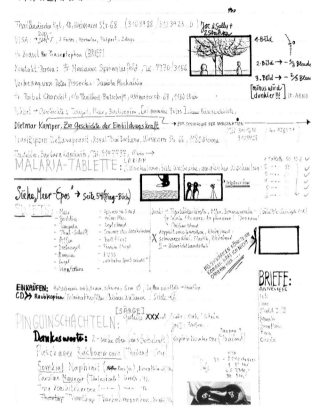

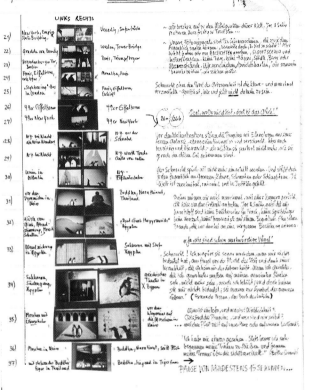

LINKS   RECHTS

MALARIA-TABLETTE:

Siehe Meer-Epos → Seite 54 (Ping-Buch)

EINKÄUFEN:
CD → Raubkopien

PINGUINSCHÄCHTELN: [SÄRGE] XXX

Dankesworte:

BRIEFE: